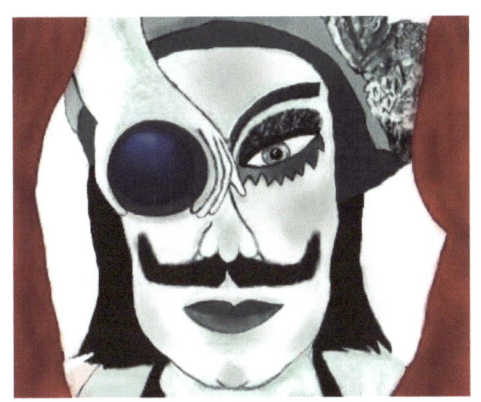

Après Vague Press

©2017 Après Vague Ltd

All rights reserved. No part of this publication may be reproduced, distributed, or transmitted in any form or by any means, including photocopying, recording, or other electronic or mechanical methods, without the prior written permission of the publisher, except in the case of brief quotations embodied in critical reviews and certain other noncommercial uses permitted by copyright law.
Published by Après Vague Press, Manchester, England.
First Edition.
ISBN-13: 978-1546375098 ISBN-10: 1546375090

MALKUTH
(The Kingdom)
Rahel Kapsaski

It all starts with nothing, negative veils of infinity

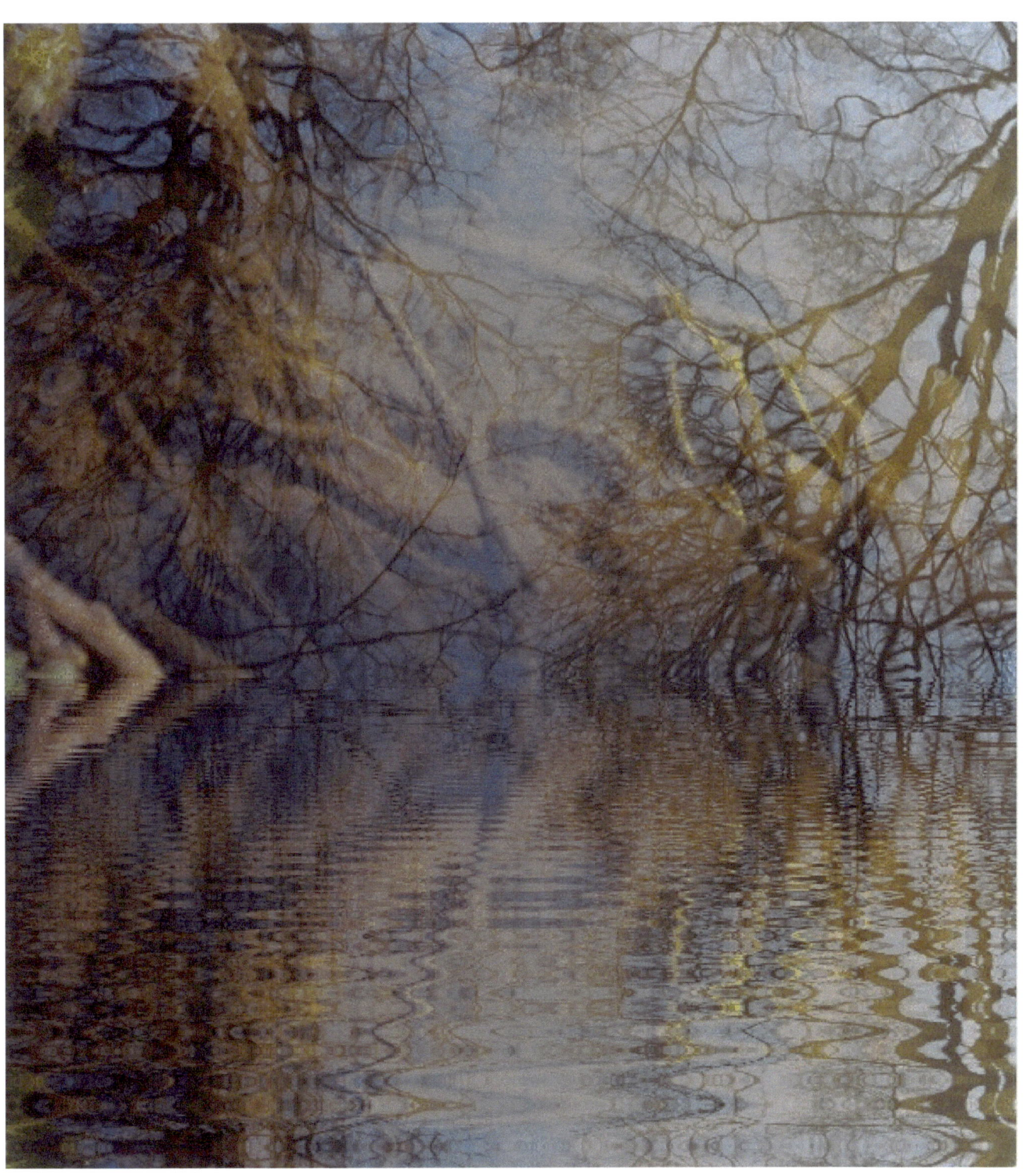

Unusual stirring delusions! Throwing the mind into an irremediable exalted state

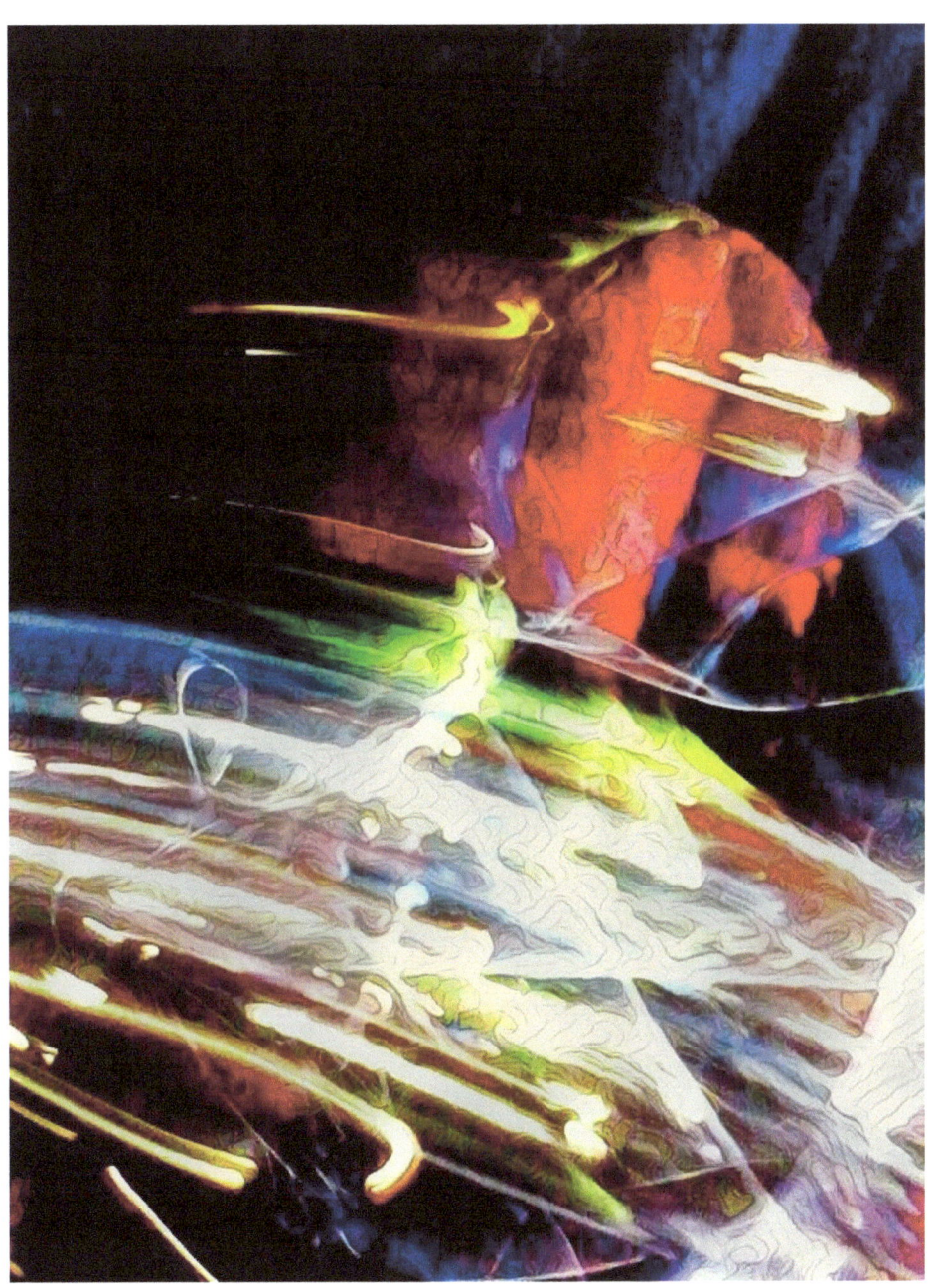

I want to follow through the 22 paths

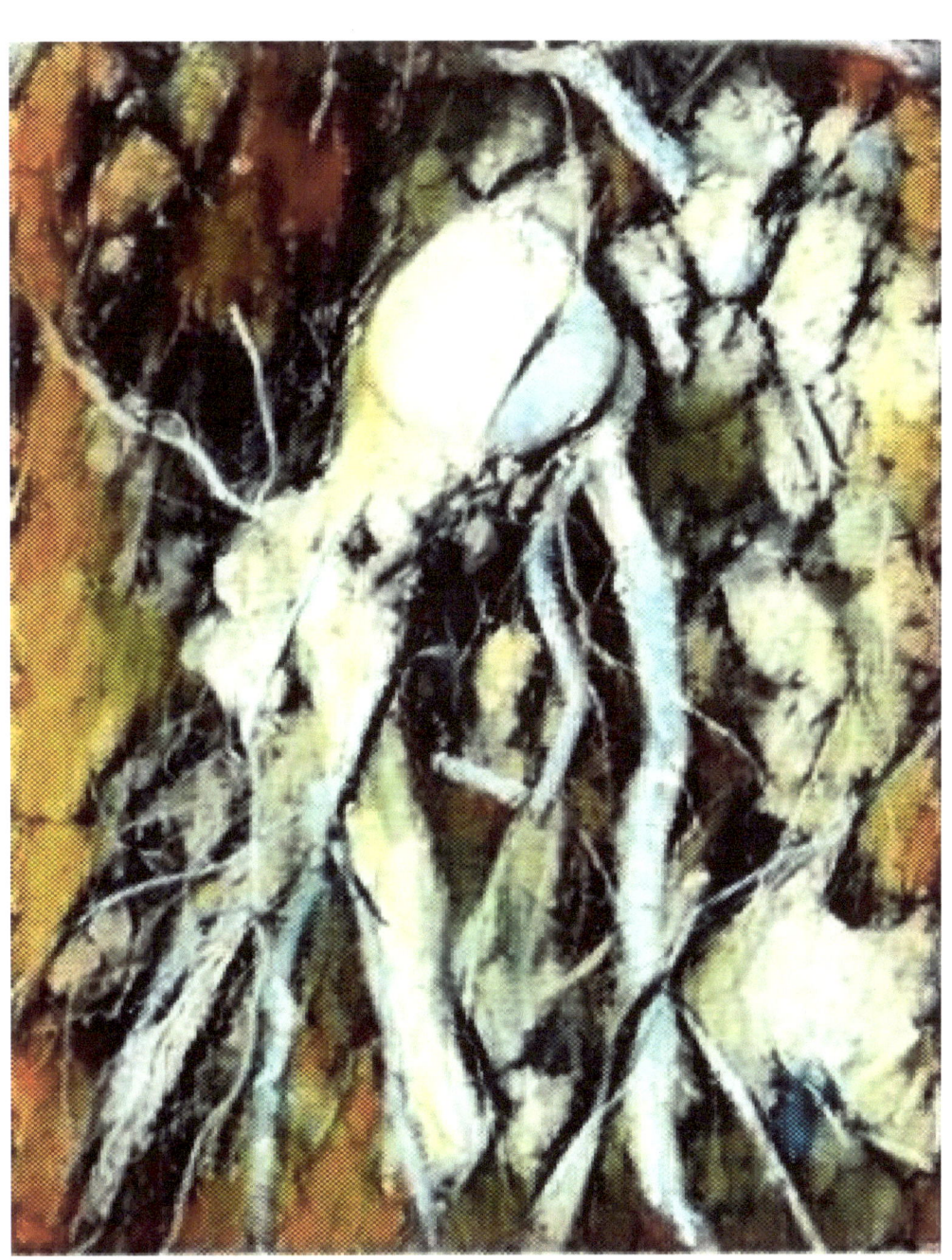

Though all doors are sealed, escape through the rusty gates

Lurch in the rotting flesh, a field of screaming mushrooms

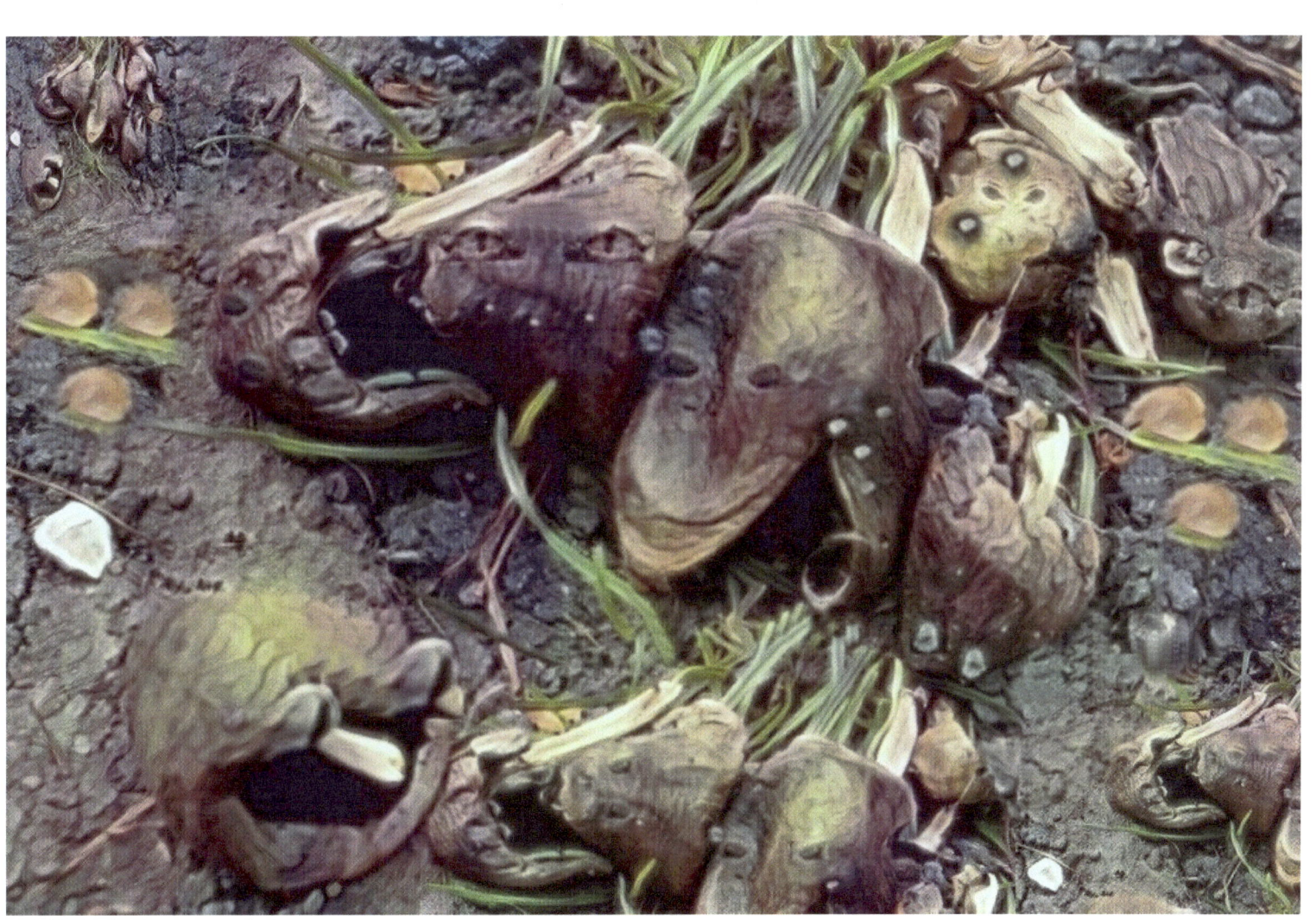

Now forcat-me-not

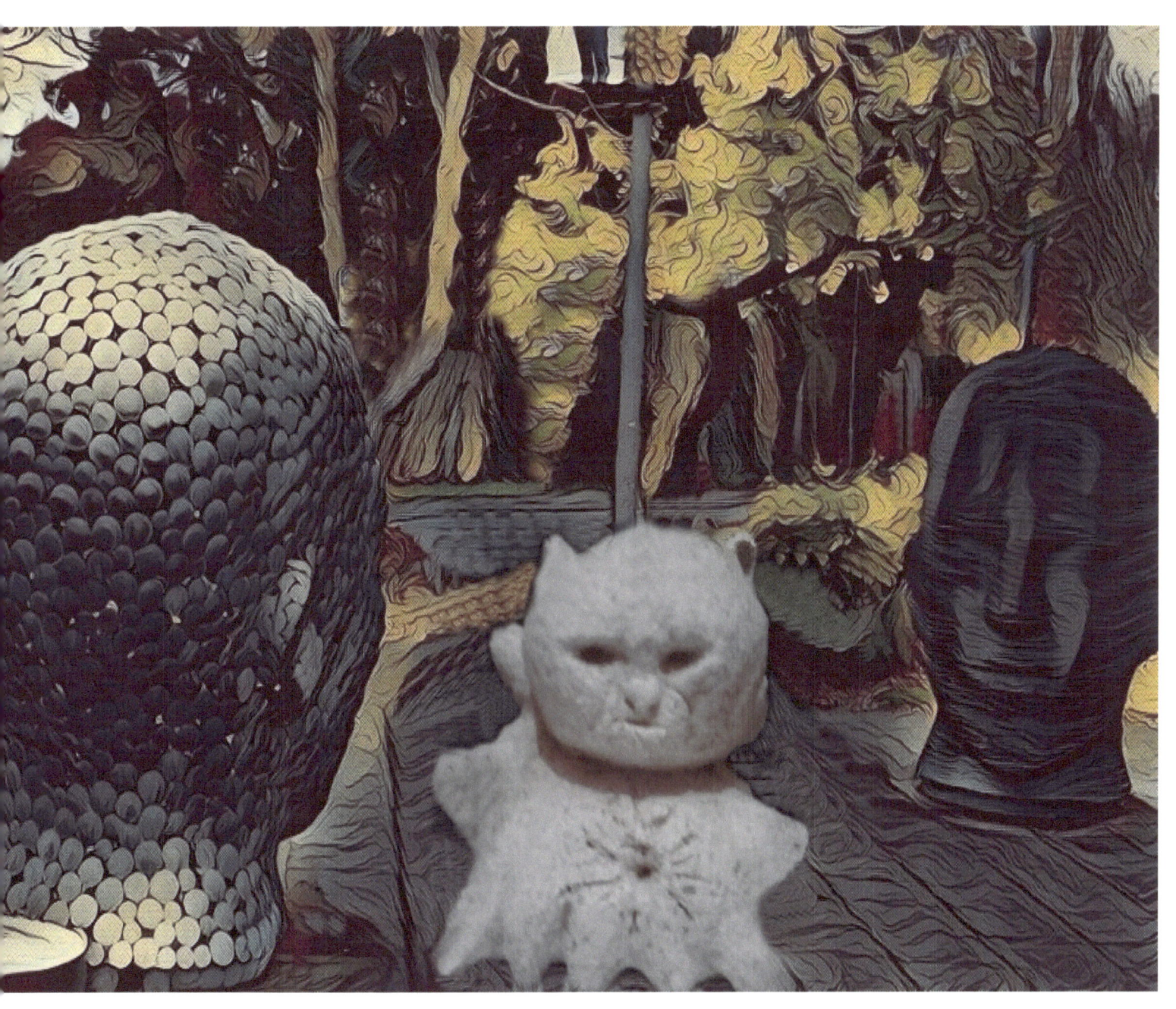

A beast with hateful eyes stares you down

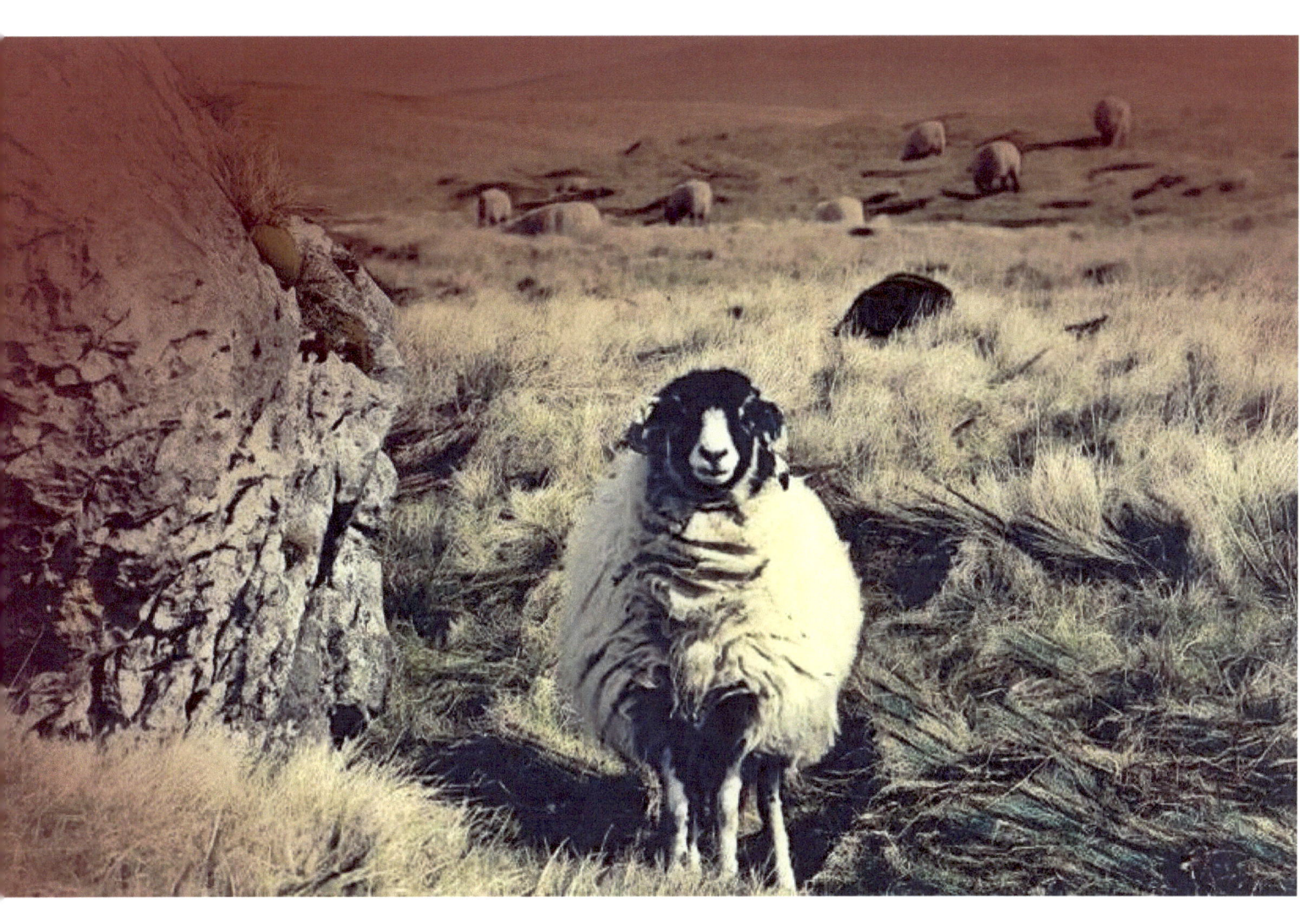

Hands turn into wire. A single feather falls,

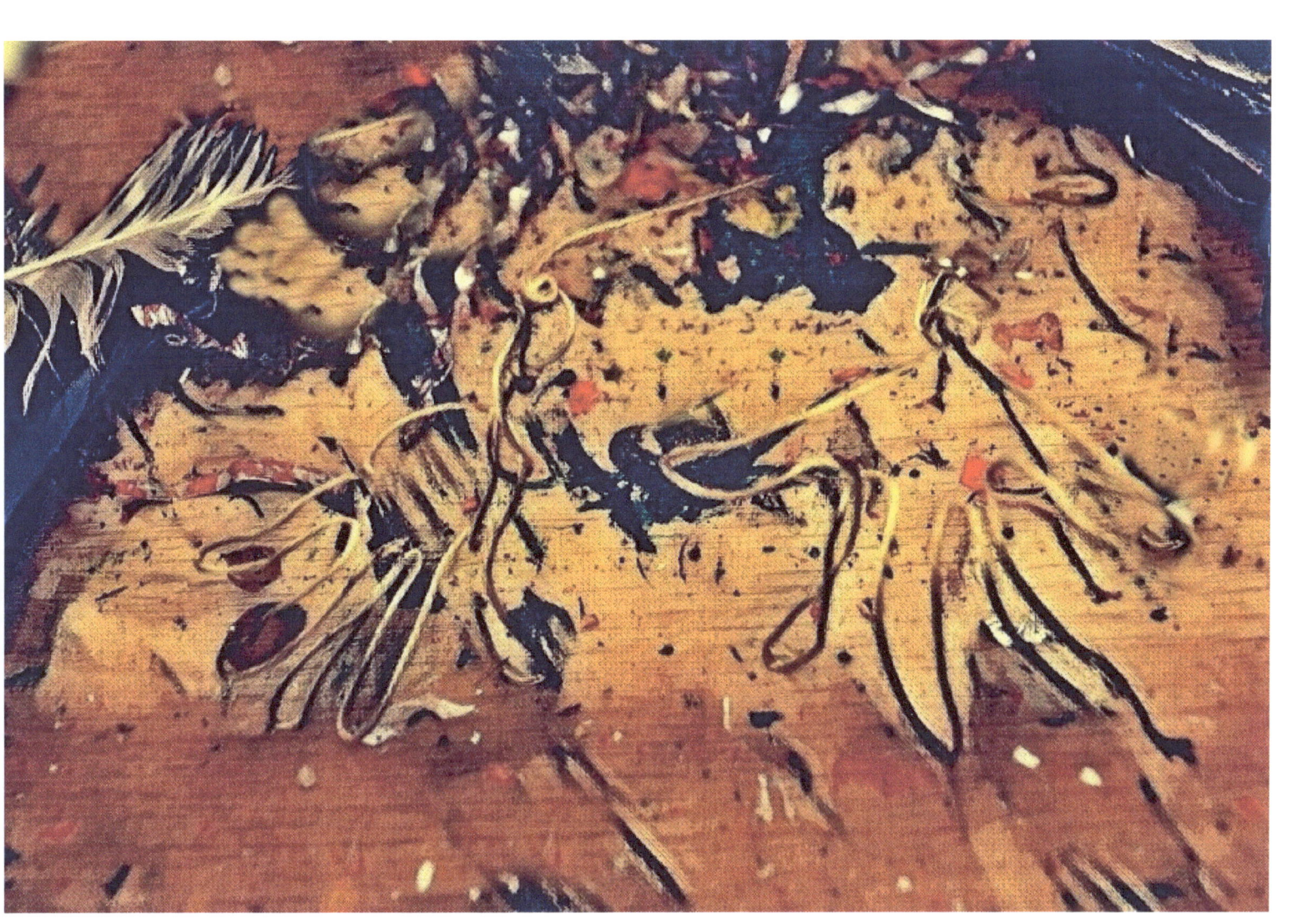

Fallen Angel

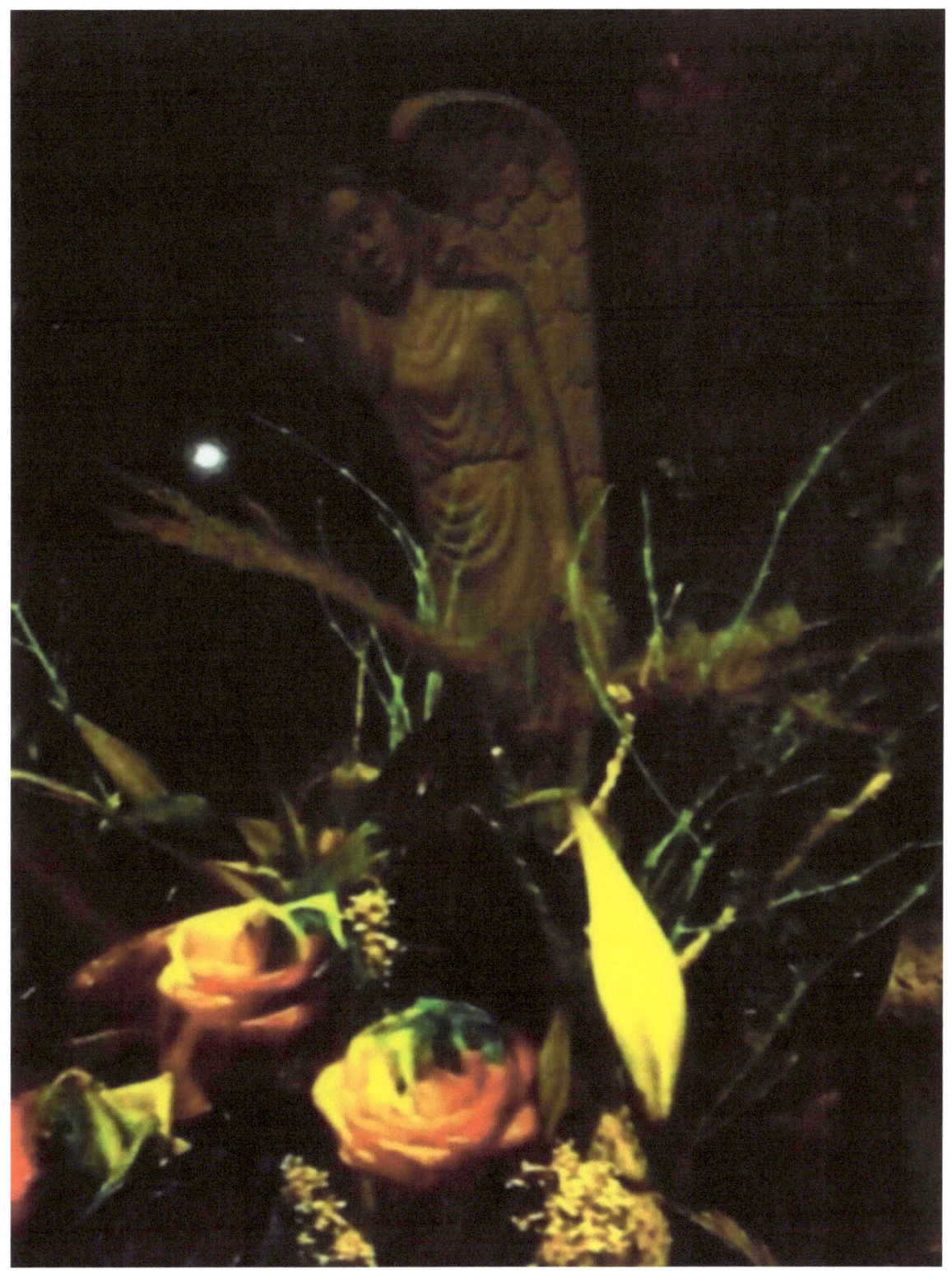

Succumb once again to the infinite roots in mirrored water

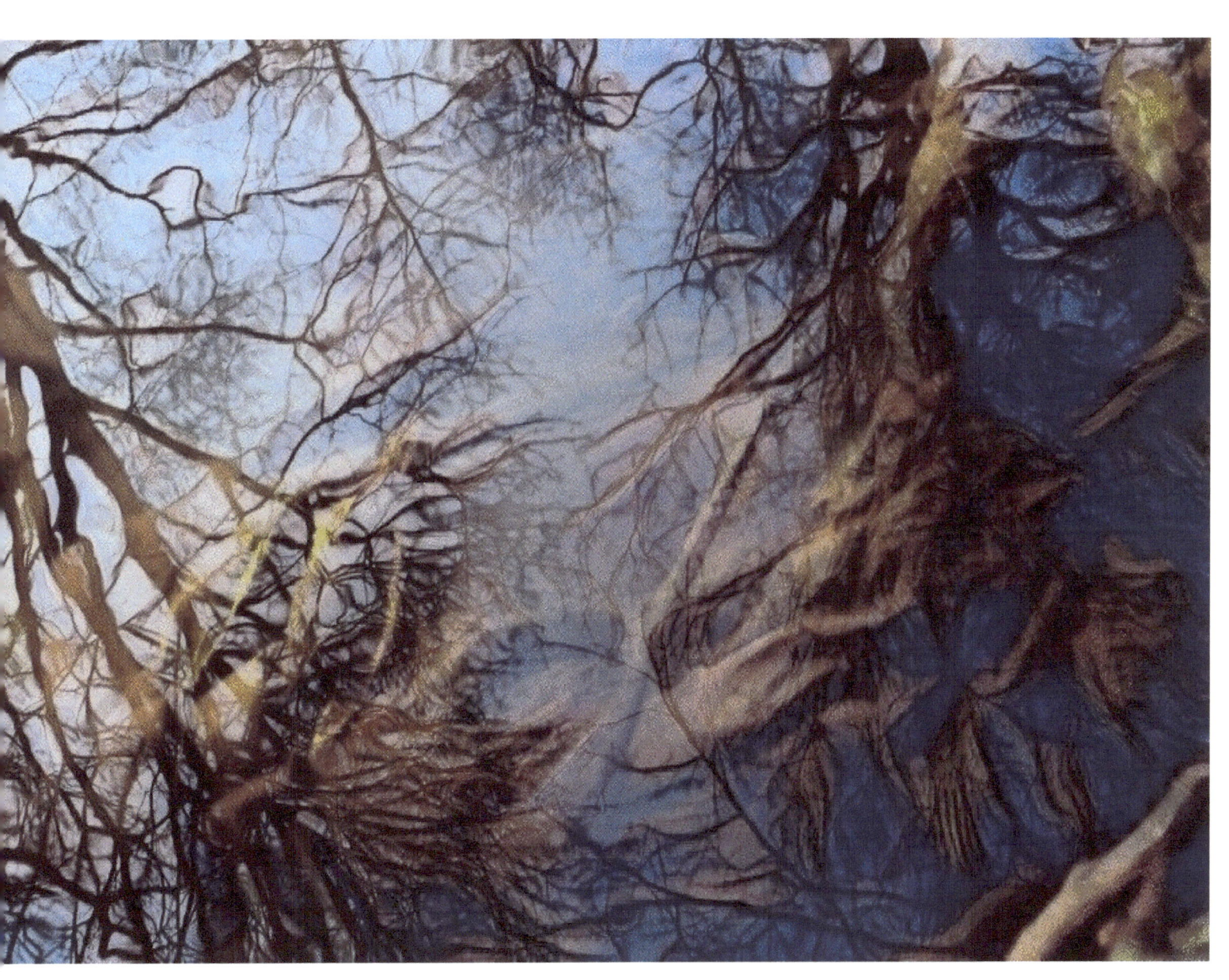

Take my spaceship to depart

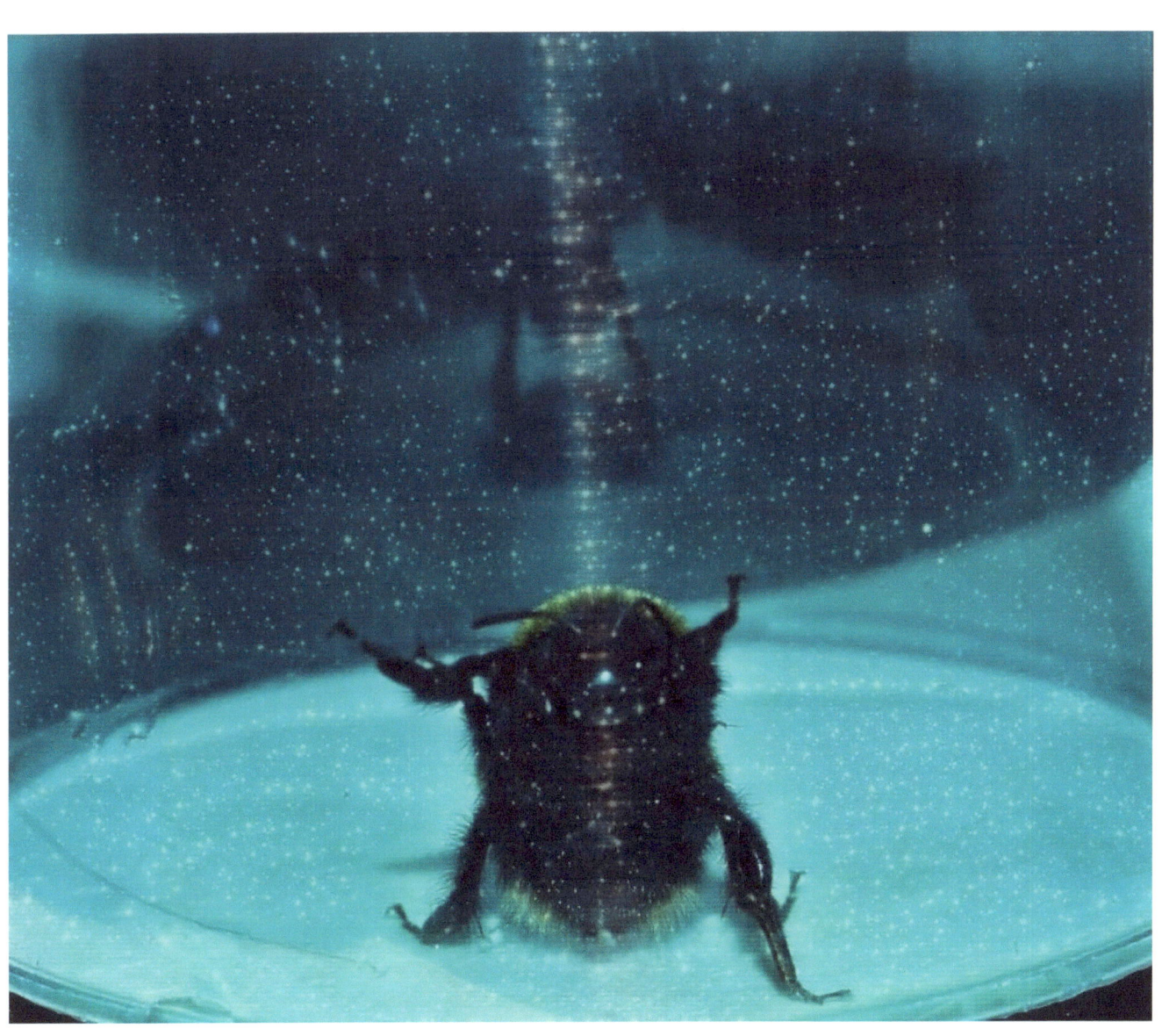

Then I shall meet you in Malkuth and worship you like Baphomet

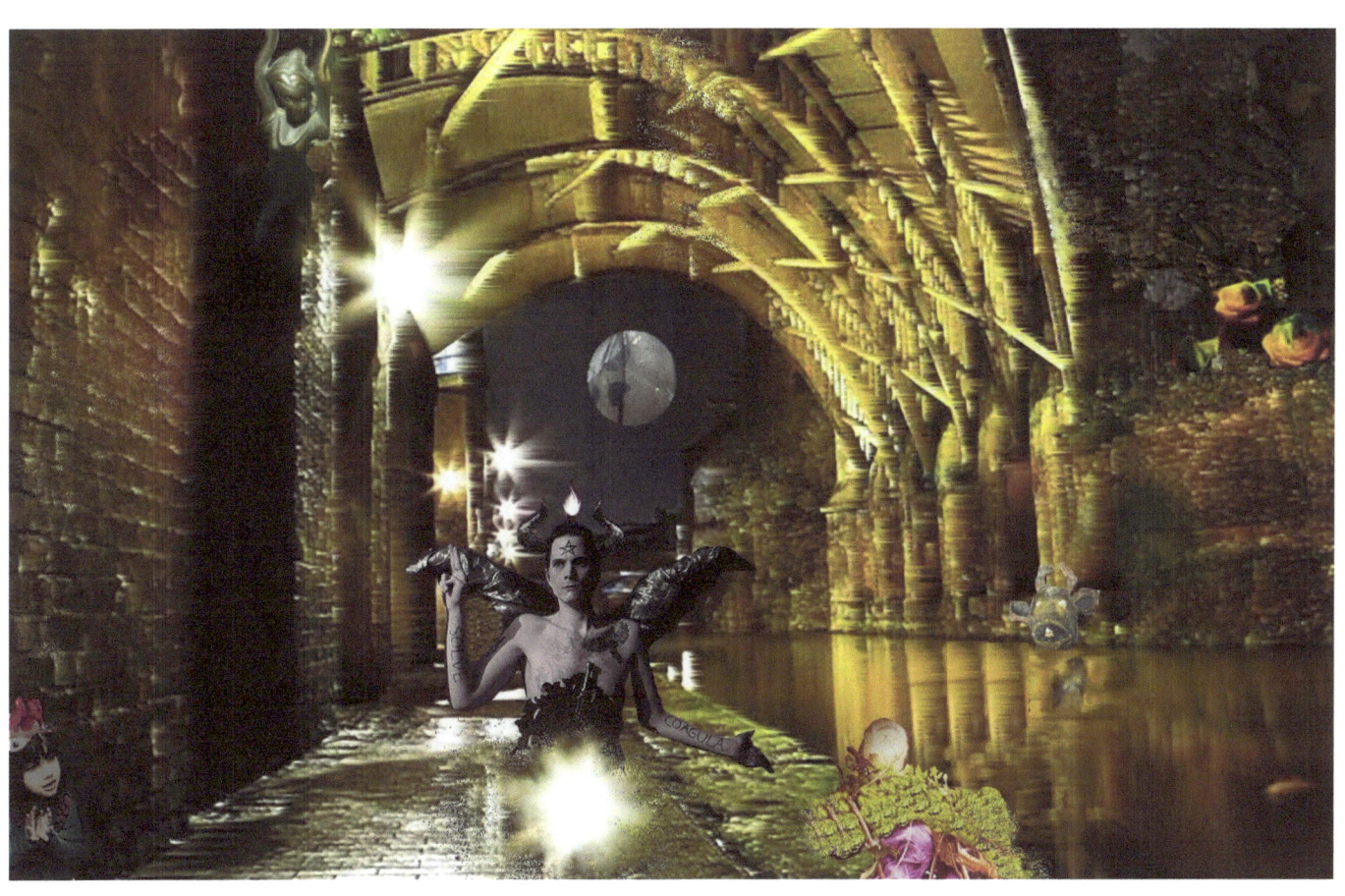

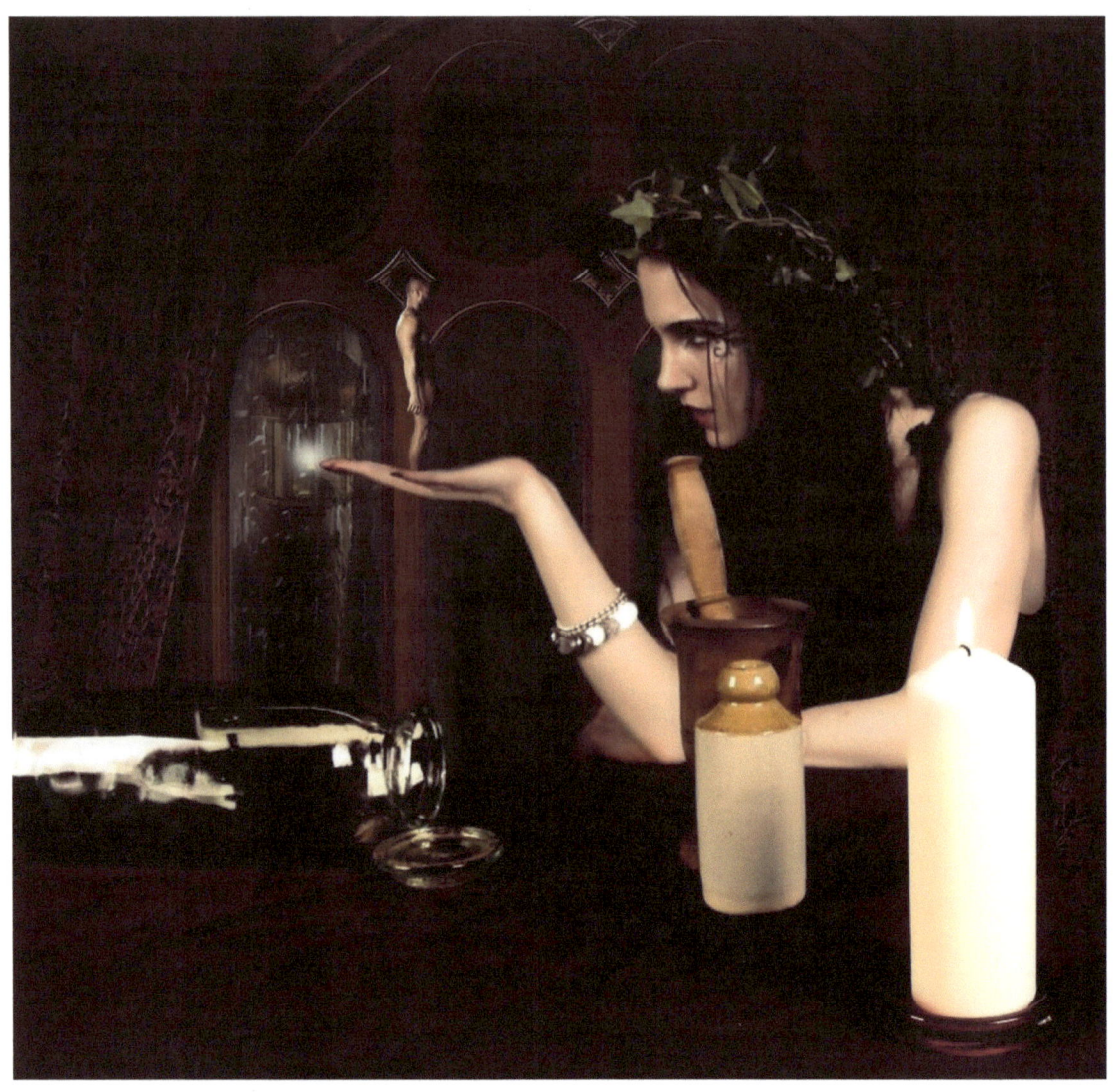

Rahel Kapsaski is a painter, actress, puppet maker and producer living Manchester, England. Rahel studied Art & Design at Manchester College and currently studies fine art at the University of Bolton. As an actress she has appeared in cult horror musical "Spidarlings" (2016) among many other. As well as theatre productions in London, Athens and at the Edinburgh Fringe Festival.

Author photo by Robin Bennett
Editing by Rachael Woodhouse

All art and photography by Rahel Kapsaski
Cover Model/Baphomet: Salem Kapsaski

Also by Après Vague Press:
Nazi Sniper by Salem Kapsaski
Second edition.
ISBN-10: 1517429374
ISBN-13: 978-1517429379

Coming Soon:
Kamikaze Dreams by Salem Kapsaski
The Sun Machine: A Literary Tribute to David Bowie

www.ingramcontent.com/pod-product-compliance
Lightning Source LLC
Chambersburg PA
CBHW041307180526
45172CB00003B/999